FROM START TO FINISH: DE WAIN VALENTINE'S GRAY COLUMN

Tom Learner

Rachel Rivenc

Emma Richardson

The Getty Conservation Institute, Los Angeles

The Getty Conservation Institute
Tim Whalen, Director
Jeanne Marie Teutonico, Associate Director, Programs

The Getty Conservation Institute works internationally to advance conservation practice in the visual arts—broadly inter-preted to include objects, collections, architecture, and sites. The Institute serves the conservation community through scientific research, education and training, model field projects, and the dissemination of the results of both its own work and the work of others in the field. In all its endeavors, the GCI focuses on the creation and delivery of knowledge that will benefit the professionals and organizations responsible for the conservation of the world's cultural heritage.

The Getty Conservation Institute
1200 Getty Center Drive, Suite 700
Los Angeles, CA 90049-1684
www.getty.edu/conservation

Design and Art Direction: Michelle Park, Commonwealth Projects
Copyediting: Clare O'Keeffe

Printed in the United States of America.

Every effort has been made to identify and contact photographers whose work may still be in copyright or to contact their estates. Anyone having further information concerning copyright holders should contact the Getty Conservation Institute.

Published on the occasion of the exhibition *From Start to Finish: De Wain Valentine's "Gray Column,"* organized by the Getty Conservation Institute and held at the J. Paul Getty Museum, Getty Center, Los Angeles, September 13, 2011–March 11, 2012.

Library of Congress Cataloging-in-Publication Data
Learner, Tom.
 From start to finish : De Wain Valentine's Gray column / Tom Learner, Rachel Rivenc, Emma Richardson.
 p. cm.
 Published on the occasion of an exhibition organized by the Getty Conservation Institute and held at the J. Paul Getty Museum at the Getty Center, Los Angeles, Sept. 13, 2011-Mar. 11, 2012.
 ISBN 978-0-9834922-1-4
1. Valentine, DeWain, 1936- Gray column—Exhibitions. 2. Sculpture materials—Exhibitions. I. Valentine, DeWain, 1936- II. Rivenc, Rachel. III. Richardson, Emma (Emma J. C.) IV. Getty Conservation Institute. V. J. Paul Getty Museum. VI. Title. VII. Title: De Wain Valentine's Gray column.
 NB237.V28A65 2011
 730.922--dc23
 [B]
 2011025986

An initiative of the Getty with arts institutions across Southern California.

Presenting Sponsors 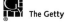 The Getty Bank of America

CONTENTS

FOREWORD

Ask any professional from the conservation field where the greatest needs are, and many will point a finger squarely at modern and contemporary art. The staggering array of materials used (most of which were never intended for artists' use), the completely unknown way in which these new materials will alter with age or respond to conservation treatments, and the idiosyncratic complications of balancing the needs of individual artists with conventional conservation approaches are just a few of the factors that routinely create challenges for conservators of contemporary art. The Getty Conservation Institute (GCI) is responding to this need by leading a major research initiative on the conservation of modern and contemporary art, and it is doing so through a number of scientific and conservation projects, as well as by facilitating the sharing of information and ideas among professionals.

Although our mission—to advance conservation practice in the visual arts—is usually focused on the professionals working in our field, raising awareness and understanding of conservation issues among a broader audience is also clearly important. After all, one of the main reasons for preserving the world's cultural heritage is to make it accessible to the public, both now and in the future. And so, as the GCI's role in Pacific Standard Time: Art in L.A. 1945–1980 gathered momentum, it became very apparent to us that a public presence would be an important opportunity to showcase some of the issues that we grapple with behind the scenes on a daily basis.

And what better example of some of these challenges than a colossal polyester resin piece by De Wain Valentine? Of all the artists working with plastics and resins in Los Angeles in the 1960s and 1970s, perhaps Valentine is unique in that he essentially had to invent a new material—one that would finally allow him to produce translucent shapes and forms at the scale he wanted. At twelve feet (ca. 356 cm) high, *Gray Column* epitomizes this extraordinary story and is the perfect focal point for an exploration of the technical aspects and conservation implications of his work.

Undertakings such as this exhibition are always the product of a great number of kind and thoughtful friends. In this particular instance, let me thank Agnes Gund, whose generous support of the GCI has allowed us to present De Wain Valentine's *Gray Column* to the public for the first time.

Finally, an introduction to this catalogue would not be complete without mentioning Valentine himself, whose warm and open personality, infectious enthusiasm, and love for art have made collaborating with him on this exhibition so rewarding, so absorbing, and—above all—so much fun.

Tim Whalen
Director
Getty Conservation Institute

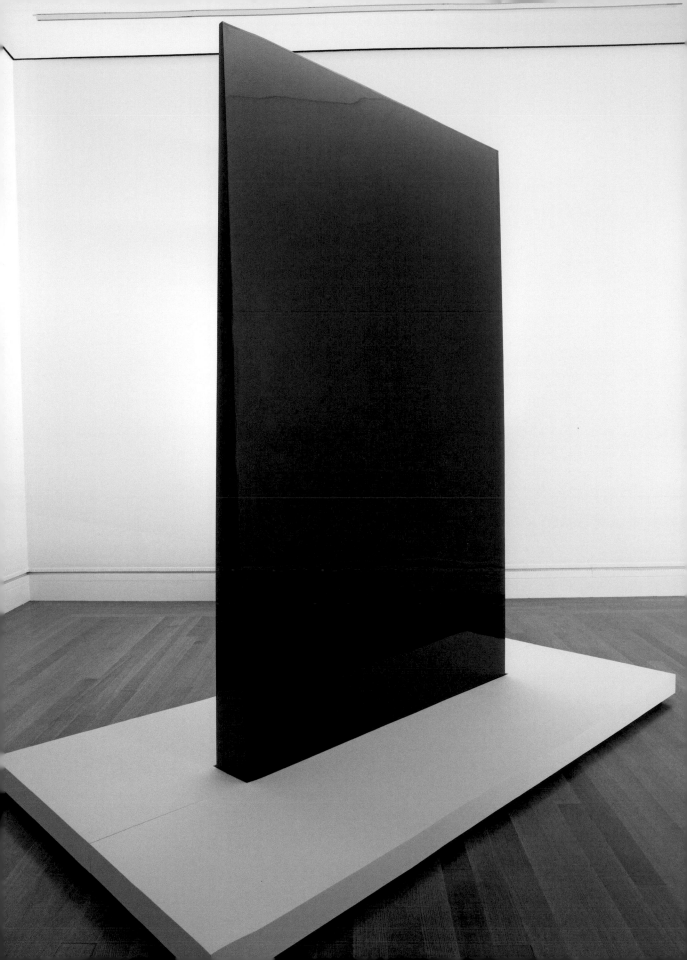

FROM START TO FINISH:
DE WAIN VALENTINE'S *GRAY COLUMN*

All the work is about the sea and the sky. I would like to have some way,
a magic saw, to cut out large chunks of ocean or sky and say, "Here it is."
—De Wain Valentine, 1984[1]

De Wain Valentine's *Gray Column* is an extraordinary work of art, with an extraordinary story behind it. At twelve feet high and eight feet across, this massive, freestanding slab of solid polyester resin towers above the viewer. Thicker and opaque at its base, it gradually tapers to little more than an inch thick at its top, almost disappearing into the ceiling, and in a certain light it is difficult to completely define its edges. But it is not a static experience either: walk around the piece and the effect changes, as different proportions of light bounce off its smooth, reflective surface and travel through it. And when viewing it from the side, one wonders just how this thirty-five-hundred-pound giant can be quite so slender and delicate.

From Start to Finish: De Wain Valentine's "Gray Column" will be the first time this monumental sculpture has ever been displayed in public and in its intended orientation. Commissioned by Baxter Travenol Laboratories for their new corporate headquarters in Deerfield, Illinois, in 1975, *Gray Column* was meant to be one of two twelve-foot columns, standing side by side. However, early in the process, Valentine learned that the architects had modified their plans for the room in which it was to be installed. Crucially, the ceilings were lowered to less than twelve feet, and Valentine opted to install the two slabs on their sides, naming the finished work *Two Gray Walls*.[2]

Thirty-five years later, one of the original *Gray Column* slabs will be installed in a manner as close as possible to Valentine's original intention, in its vertical orientation, albeit without its partner slab. The focus of the exhibition, however, is much broader than the history of the single piece it displays. *From Start to Finish* reveals the story of the technical innovation behind the making of this polyester piece.

Valentine was part of a group of Los Angeles based artists who, in the 1960s, became renowned for adopting new materials and innovative fabrication processes, often borrowed from the industrial world. The sensuous colors and beautiful, pristine surfaces that were often painstakingly achieved by these artists earned them the label Finish Fetish. Although Valentine has been associated with this loose group, and later with the Light and Space artists, his artistic sensitivity was also independent and somewhat fully formed when he moved to L.A. in 1965. By then, he was already a recognized sculptor in his native state, Colorado, and had established dialogues and friendships with some of the major East Coast artists such as Roy Lichtenstein, Claes Oldenburg, and Carl Andre.

He had also already started working with plastics. As early as 1950, he had started making jewelry with cast polyester resin, a semi-transparent material that could be molded, delicately colored,

and extensively polished to create a wide range of prismatic effects. He was so proficient with the material that he taught a course in plastics technology at the University of California, Los Angeles (UCLA), soon after he moved to Los Angeles. He continued to work with polyester resin through the 1960s and well into the 1970s. The ability of the material to transmit, diffuse, or refract light was perfectly suited to Valentine's artistic pursuit: the creation of objects that allowed the viewer to "become involved with both the inside space and the outside space or surface—where most sculpture visually stops."[3] The Southern California landscapes, with the omnipresence of light, immense skies, and vast ocean views, became a unique source of artistic inspiration for him, and one that was in perfect synergy with the medium he had already chosen.

There were limitations, however, to what could be achieved in the mid-1960s with polyester resin, especially in terms of scale. At that time, the available resins could only be molded in small volumes, because the intense heat generated by the curing process would cause larger pieces to crack and break apart, as well as being inherently hazardous. But Valentine wanted to work on a much larger scale, and the only way that was possible would be to pour the resin in several sessions, allowing each thin layer to cure before applying the next. Far from accepting these limitations, Valentine was determined to increase the scale of his sculpture without compromising the overall aesthetic or the process.

And so began the remarkable story of an artist driving the development of a new material. Quite by chance, Valentine met Ed Revay, a local sales representative from the Pittsburgh Plate Glass Company (now known as PPG Industries), at Hastings Plastics in Santa Monica. Revay took an immediate interest in Valentine's work and started bringing him new resins that were not yet commercially available in California. Valentine experimented relentlessly and meticulously with these resins, varying the ratio of their components, until they came up with a new polyester resin that could be cast in very large volumes in a single pour. The resin came on the market in 1966 under the trade name Valentine MasKast Resin, distributed by Hastings Plastics, and Valentine's series of human-scale columns, slabs, and discs quickly followed.

The development of this resin was clearly a major turning point in Valentine's artistic evolution. Freed from the constraints that limited the size of his pieces, he could now work on a scale that related his sculpture more to architecture than to objects, modifying the surrounding space and creating interactive sensorial experiences. *Gray Column,* with the technical achievement and invention it represents, is the perfect focal point to highlight the importance of materials and processes in the creation of contemporary artworks.

From Start to Finish also explores some of the conservation issues surrounding the artwork, issues that ensue directly from the way it was made and the way it was meant to look. For in spite of their monumentality, Valentine's sculptures are inherently fragile. Small damages such as scratches

and chips have the potential to ruin the entire effect of the sculpture. Helen Pashgian, a contemporary of Valentine's who also worked extensively with plastics, recently explained in clear and striking words how truly essential a perfect finish is to these artworks, "On any of these works, if there is a scratch . . . that's all you see. The point of it is not the finish at all. The point is being able to interact with the piece, whether it is inside or outside, to see into it, to see through it, to relate to it in those ways. But that's why we need to deal with the finish, so we can deal with the piece on a much deeper level." [4]

Another change that can occur in these pieces has nothing to do with accidental damage. Valentine's cast polyester pieces are also likely to develop surface imperfections that appear as ridges or an "orange peel" pattern over time. Valentine calls these "grow-outs," and they are related to a curious property of polyester resin, whereby the material remains capable of continued, albeit very slow, movement long after it is cast. This phenomenon could be considered a natural aging characteristic of the resin itself, just as an oil paint starts to yellow with age, or bronze develops its patina. However, for Valentine, these changes have the same effect as accidental damage—they draw the viewer's eye to the very place that he does not want it to be—the surface of his work.

And so pieces are routinely resanded and repolished to bring the surface finish back to a pristine condition, and the accompanying, inevitable removal of original material is typically viewed as an acceptable loss. However, the conflict between the necessity of respecting Valentine's intent and the need to preserve his original materials, traditionally considered the guarantee of an artwork's authenticity, is acute. Valentine pushed the industrialization of his creative gesture as far as possible at the time, yet he never delegated to a fabricator. All of his pieces were handmade in his studio, by him and his assistants. Their surfaces were meant to look pristine, but at the same time they bear all the barely visible imperfections left by the hand of the artist and the tools he used. These are important documents of the time of creation of the artwork, yet they are irreversibly erased when the surface is repolished.

These are dilemmas that confront conservators of contemporary art routinely. There are no easy solutions to them, and it is hoped that *From Start to Finish* can extend the dialogue among artist, conservator, and custodian of the work to the public at large.

1 *A Good Time to Be West: 12 California Sculptors,* directed by Robin Lough (1984; Los Angeles: California/International Arts Foundation, 2010), DVD.

2 Valentine named his wedge-shaped polyester slabs Columns if they were taller than wide, and he named them Walls if they were not. *Two Gray Walls* was later reacquired by Valentine.

3 De Wain Valentine, from "De Wain Valentine" (includes interviews with the author, 1979–81) in *The Art of Light + Space,* by Jan Butterfield (New York: Abbeville Modern Art Movements, 1993), p. 191.

4 Helen Pashgian, "Modern Art in Los Angeles: The Industrialized Gesture" (conversation with Peter Alexander, Helen Pashgian, and De Wain Valentine, Getty Center, Los Angeles, May 19, 2010). www.getty.edu/research/exhibitions_events/events/industrialized_gesture/index.html.

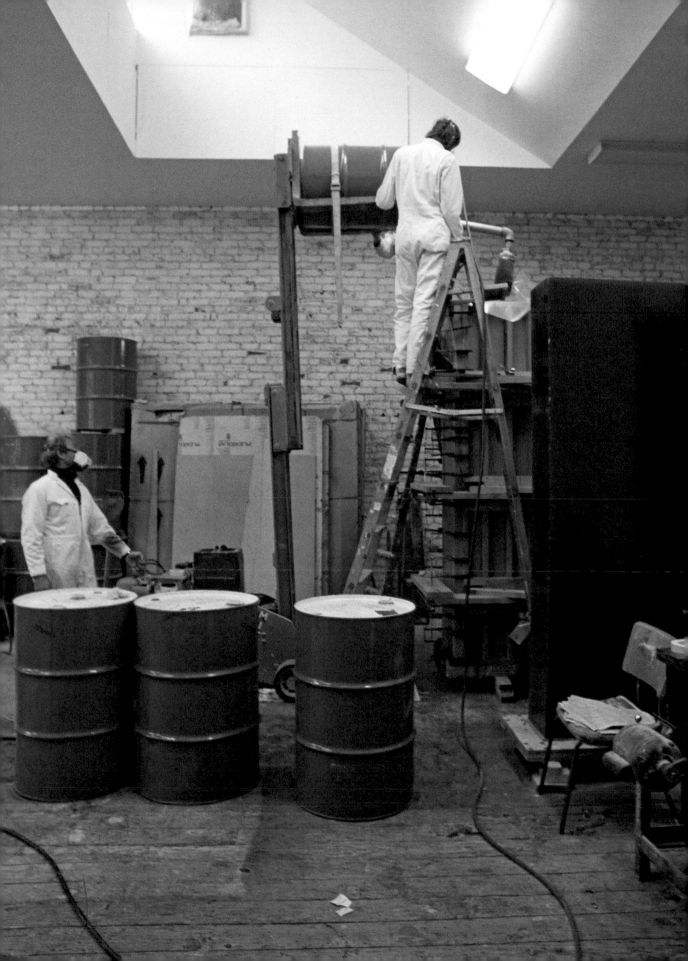

IN CONVERSATION WITH
DE WAIN VALENTINE

Do you remember how you first became interested in art?

I always wanted to draw horses. I was a real "horse kid"—my daddy was a cowboy from Texas.
When I was a young boy living in Colorado, I'd sit on the floor of the living room, looking at the
Sunday comic section of the *Denver Post,* and try to make sense of how the horses were drawn in
Prince Valiant. Horses are very hard to draw! But when I got to junior high, I stumbled on a book
in the public library of old master drawings and saw all these beautiful drawings of naked women.
I thought, "to hell with horses!"

What inspired you to turn toward sculpture, in particular pieces that interact with light?

I had an early fascination for rocks and gems. My mother's family had emigrated from Europe to
the high mountains of Colorado to search for gold. I remember walking around the mines with
my great uncles; they would spit on scraps of ground ore to show me how magical they became
when wet. Later on we lived in Lander, Wyoming—which is something of a gemstone capital for
agates, jades, and beryl. The Air Force had a bombing range there, and my daddy worked on a
pipeline that ran right through it. After a bombing session, we'd walk around the range and find
all these moss agates and hunks of jade just lying on the ground, and they glowed beautifully in
the light if it had just rained. I guess I was always interested in that kind of transparent colored
space. The outside surface of a jewel is stunning, of course, but I was always mesmerized by the
inside, the light coming from beyond.

How did you start working with plastics and what attracted you to them, especially polyester?

It was my junior high school shop teacher, Mr. Warren, who first introduced me to plastics. The
first plastic he showed me was acrylic, which had just been declassified by the Air Force after
World War II. He told me I could cut it, stain it, polish it, and make my own stones. So I started
working with that, and it was a lot easier than cutting and polishing stones! But very shortly after
that, around 1947, the Navy declassified fiberglass and polyester resin, and a lot of the surplus was
given to the school shop, just like the acrylic. My second-year teacher, Mr. Knight, said, "Look at
this, De Wain: Mix a little bit of this and a little bit of that and your own color, then cut it, polish

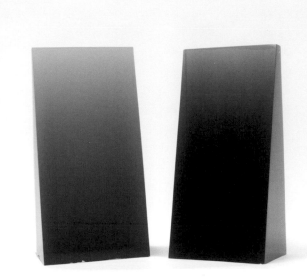

it, and you can make your own jewels!" I just had this immediate affinity for that material. With a lot of sculpture, all you really see is its shell, its exterior surface. But with polyester I could make pieces that you could look right into, and through to the other side. Your eyes didn't get hung up on the surface anymore. You were able to encompass the whole piece and see how it interacted with light.

Why did you move to Los Angeles in 1965? Were you interested in other artists working there?
I'd always wanted to move to L.A. or New York, but New York was unthinkable for an artist with no funds and three kids. So California was the big dream. I followed what was happening on the East Coast, of course, but I was more interested by what was happening in Los Angeles. I'd seen the work of many of those guys, Larry Bell and Craig Kauffman, for example. And then *Artforum* magazine came out and started publishing all that great stuff about Tony Berlant, who was soaking clothes and underwear in polyester and hanging them on a clothesline. No one had ever done anything like that before—it was very inspiring! In New York, I'd also had experiences of gallery people getting very interested in my work from photos and slides, but when they learned it was made from plastic, and not bronze or steel, they would quickly say, "We don't want to show anything made of plastic." In L.A. it was just far more readily accepted for artists to work in resin and plastic. I also had a very good friend, Jack Hooper, who taught in the Art Department at UCLA. I met him when he was an invited artist at the University of Colorado, and he came to see me to learn about plastics. He offered to put me and my family up in his house and got me a part-time job at UCLA, teaching art students how to use plastics. That really helped!

Was Los Angeles a source of inspiration in other ways?
Yes, the landscapes definitely were: the skies and the ocean in particular. I had done clear pieces already in Colorado, but in L.A. I saw a new avenue to make sculpture that was completely atmospheric or like a chunk of the ocean cut out. In Colorado, you don't notice the sky so much because it's crystal clear: always blue and always so beautiful, but you can't see it, so you always forget about it. But the sky in L.A. is very different: You really see that—the smog and the fog!

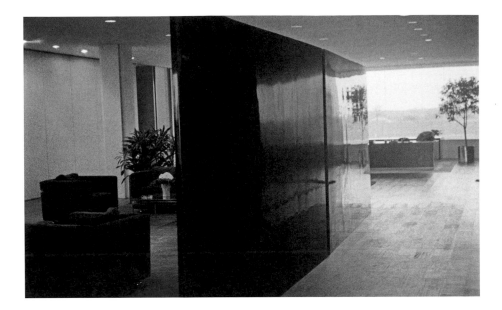

I was living in Venice, right next to the ocean, where there was this marine haze. The light gets diffused by the marine layer and creates that beautiful, sparkling, silver light.

Did you immediately connect with other artists in L.A.?
Pretty much. Jack Hooper knew everybody in the art world, and by the end of the first or second week I was here, he had already introduced me to Ed Moses and Bob Irwin. Within a month, he decided I should meet some architects to see if I could get some architectural commissions and introduced me to David O'Malley and Frank Gehry. David, Frank, and I became great friends. I got the studio on Market Street [Venice] in 1966, and Larry Bell moved into the same street shortly after. And I met many of the others around that time: Billy Al Bengston, Kenny Price, and all those guys. It wasn't so easy to jump into that circle of artists, but eventually everyone became very open and came over to the studio to see what I was working on. Before long we were all in each other's studios all the time.

You weren't the only artist in L.A. working with new materials like plastics and resins, but unlike everyone else, you essentially invented a new one. Why did you need to do that?
Well, when the polyester resins that were available back then cured, they would give out so much heat that the pieces would crack really badly if there was more than a thin layer being cast. But I really wanted to work on a much larger scale. Some artists were able to make larger pieces by slowly building up layers of polyester, but that never worked for me. What I needed was a resin that could create large volumes from a single pour. I was fortunate enough to meet Ed Revay, the local sales rep for the resins division of PPG (Pittsburgh Plate Glass), by chance, at Hastings Plastics one day. He really took an interest in what I was trying to do, and we worked together to find and develop a new resin that would allow me to make the large pieces I wanted.

So how did you actually create the new resin?
Ed brought to my studio samples of new polyester resins that they were developing on the East Coast, or I'd pick them up from the PPG plant in Torrance. That was some place—it seemed like

the end of the world at the time! I experimented with these resins for days and days, trying to find the right ratio of resin to catalyst. I also knew that temperature had a huge effect on how the resin cured, so I watched that too. I had to do really precise measurements, like a prescription. I used a gram scale to weigh out the catalyst, recorded the temperature, and kept meticulous notes in my diary of everything—my bible! I'd then let Ed know how it went, and we would either continue with a product, or he would bring a new resin. Eventually we came up with a product that worked. And then there was no stopping me!

And Hastings Plastics sold the resin under your name as Valentine MasKast Resin?
Yes, that's right. Norry Hastings, the owner at the time, became a good friend of mine after I moved to L.A., and he came up with the idea of distributing the resin. I also got Hastings to supply me with a dozen barrels at a time, instead of ten, which was a normal batch. That way, for the really big pieces like *Gray Column,* I had two barrels to figure out what the darn stuff did, and the other ten to use. By that time we had it all metered out and everything was measured out gram by gram.

Is *Gray Column* one of the largest sculptures you made with the new resin?
Definitely! *Gray Column* is twelve feet high and eight feet wide, and was cast from ten barrels of polyester, each weighing five hundred pounds. I did several casts of this piece. Each one took about eighteen hours to pour: It took an hour to mix the pigment and catalyst into the resin inside each barrel, and then an hour to force the resin out of each barrel through a filter and into the mold. It was really challenging and dangerous to make these big pieces. I usually had them sitting by the back door in the studio in Venice with a forklift positioned right behind them, ready to push them out into the alley if they started to overheat and burn. I remember the sound more than anything else: With all the pressure pushing out on the sides of the mold, there were cracking and snapping sounds the whole time—like pine logs burning in a fireplace!

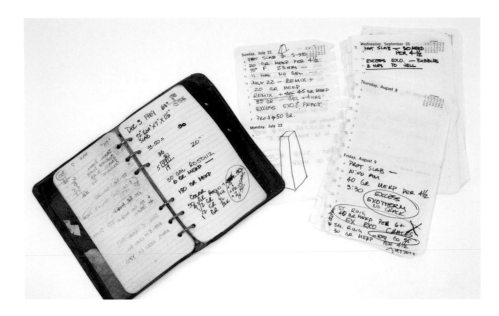

Did the process ever go really wrong?

Oh yes! I lost many pieces. In fact, an earlier casting of *Gray Column* cracked very badly in the mold and had to be thrown out. When you make mistakes at that scale, it gets very expensive! Even with the new resin, different batches and different volumes still behaved differently. The other large piece that I so nearly lost was *Large Wall,* now at the Norton Simon Museum. I made that in 1968, and it was the biggest piece I had attempted at that point—I really had no idea about the amount of pressure that would be exerted on the walls of the mold during curing. I got about nine barrels into the mold, when it just started to break apart! Luckily, Larry Bell, who had the studio next door, came over to complain about the stink, but when he saw what was happening, he ran back to his studio to grab timbers, and three friends that were visiting him, and we strapped the timbers around the mold with pipe clamps. I managed to get the last barrel of resin into the mold just as it was starting to set. I always get a kick out of that story because Larry was so terrific in helping me.

How do you give your works this beautiful smooth surface?

Lots of sanding and then lots of polishing! For sanding I used an automobile body fender grinder and different grades of sandpaper, starting with the coarsest (sixteen grit) working up slowly to the finest. Six hundred was the finest grit at the time. Nowadays, the grades of sandpaper go up to at least six *thousand*—which is even smoother than a baby's bottom! But we were more limited at the time. For the biggest pieces, I had two, sometimes three assistants helping me: Chris D'Arcangelo, Rob Janiger, and Keith Anderson. It still took months.

The piece we are displaying is called *Gray Column,* but it was installed before on its side, as part of *Two Gray Walls.* Is that correct?

Yes, exactly. It was a commission from Baxter Travenol Laboratories, for their new headquarters in Deerfield, Illinois. The commission came through an architect firm, Skidmore, Owings & Merrill, who got me a lot of work in the Chicago area. I had intended the piece to be *Two Gray Columns*—in other words, two of these twelve-foot-high polyester columns installed side by side.

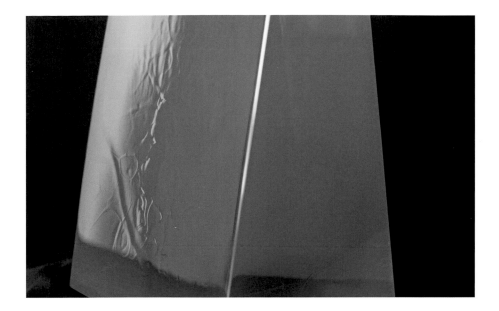

But the architectural plans were changed somewhere along the line, and they decided to lower the ceilings to under twelve feet. So it was no longer possible to have the columns standing upright. Instead of starting all over, I decided to modify the work and install both slabs on their sides. I renamed the work *Two Gray Walls*, as I've only ever considered pieces that are taller than they are wide to be called Columns. Believe it or not, I have never seen any of the slabs upright, as I had originally intended them. They were cast on their side, sanded and polished on their side, shipped on their side, displayed at Baxter on their side, and have been stored ever since at my studio on their side.

Is *Gray Column* perfectly symmetrical?

Actually, no. Whenever I made Columns or Walls, I always shaped them slightly so they were narrower at the top. This is an old trick to make things appear even taller: the Romans used it on all their columns, for example. So for its installation as *Two Gray Walls*, the shaping was done with the piece on its side. Now that we have it installed upright, the narrowing is not in the right place! I had many discussions with the curators of this exhibition about whether we should reshape the piece for its new orientation, or whether we leave it for now. In the end we decided to leave it alone—it's certainly part of the history of this piece.

Do your polyester pieces alter with age? Is that a concern for you?

Polyester is a pretty durable material, as long as you protect it from UV light, which I did, and you don't mishandle it. But sadly it is really easy to scratch and mark its surface. One curious property, though, is that polyester is similar to glass in that it keeps flowing even though it has the appearance of being completely solid. Patterns appear on the surface; some are definite lumps or ridges, and I call those "grow-outs," others look more like orange peel. They can appear quite quickly, within a year of polishing, but they can also keep occurring for much longer—sometimes up to thirty or forty years. I was chagrined when I first saw them appear, but soon I realized I just needed to resand and repolish my pieces to get the pristine surface back. Of course I want my work to last—at least for as long as I am around!

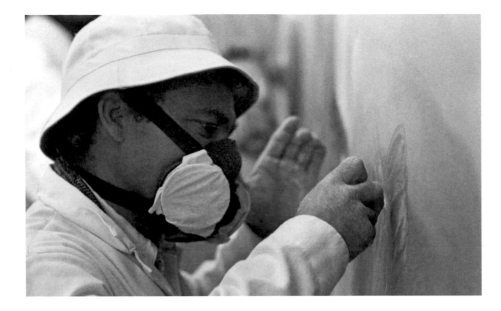

And what happens if a piece gets scratched? Do you tolerate any kind of damage like that?

No. My polyester work needs to be pristine, because if there is a scratch anywhere, all you see is the scratch. The surface needs to disappear as much as possible, so you can look through it to the inside of the piece and out to the other side. A scratch or other damage only draws attention to the object's surface. Most sculpture is a skin; your eyes stop at its surface and you only see the outside. But with my cast polyester pieces, the interior of the sculpture is so essential. So they get refinished whenever it's needed. Of course when you do that, a small amount of material is always removed from all over the surface, so I guess if you kept doing it, the object would eventually get completely worn away, but that's definitely a very long way off!

Why did you stop using polyester resin?

Well, I had always wanted to make pieces that would go outdoors, and polyester was not suitable for that—it deteriorates in sunlight. So I turned to glass. *Gray Column* was one of my final polyester pieces, if not quite the last. I quit using the resin shortly afterwards, and PPG quit making it. I have to say, I really don't miss worrying about the toxicity of the material.

Finally, are you looking forward to seeing *Gray Column* upright?

Are you kidding? I've wanted to see that piece standing upright in some place ever since I did it! And it's great that we'll also be telling the story behind the making of *Gray Column.*

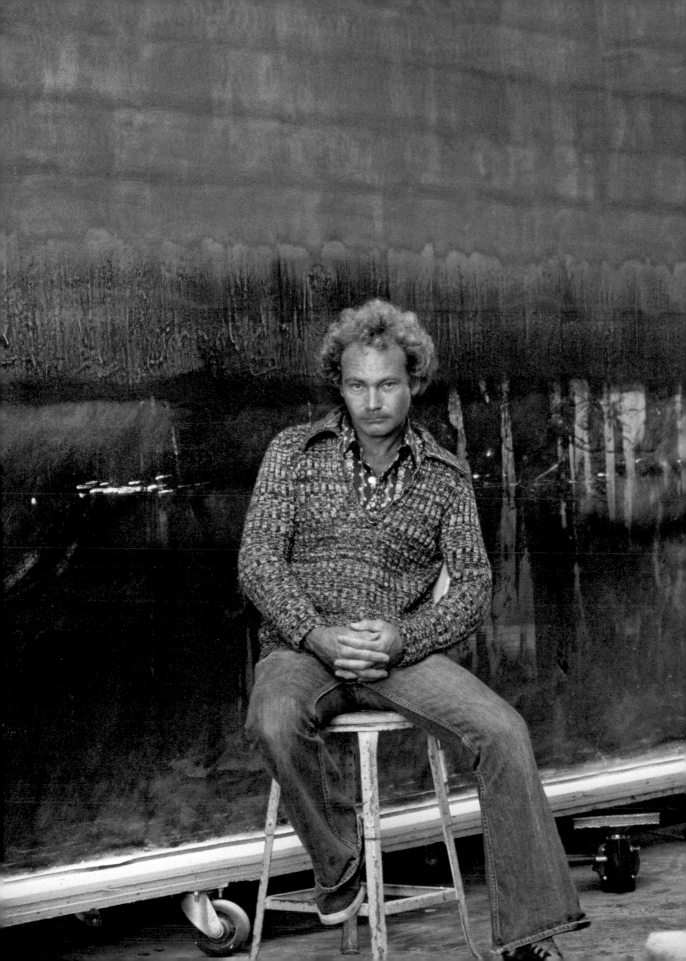

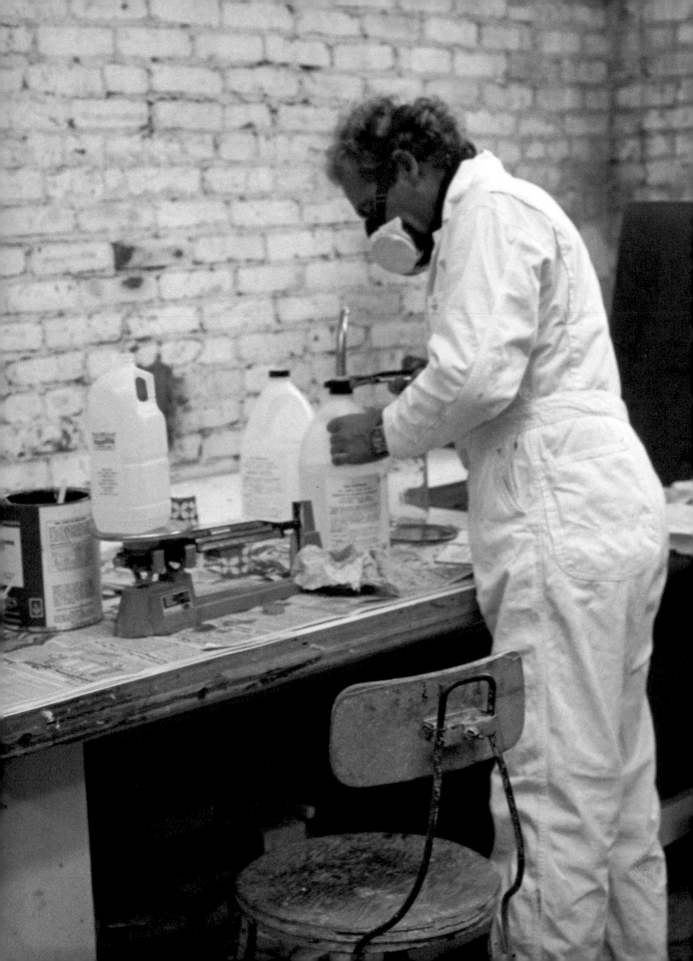

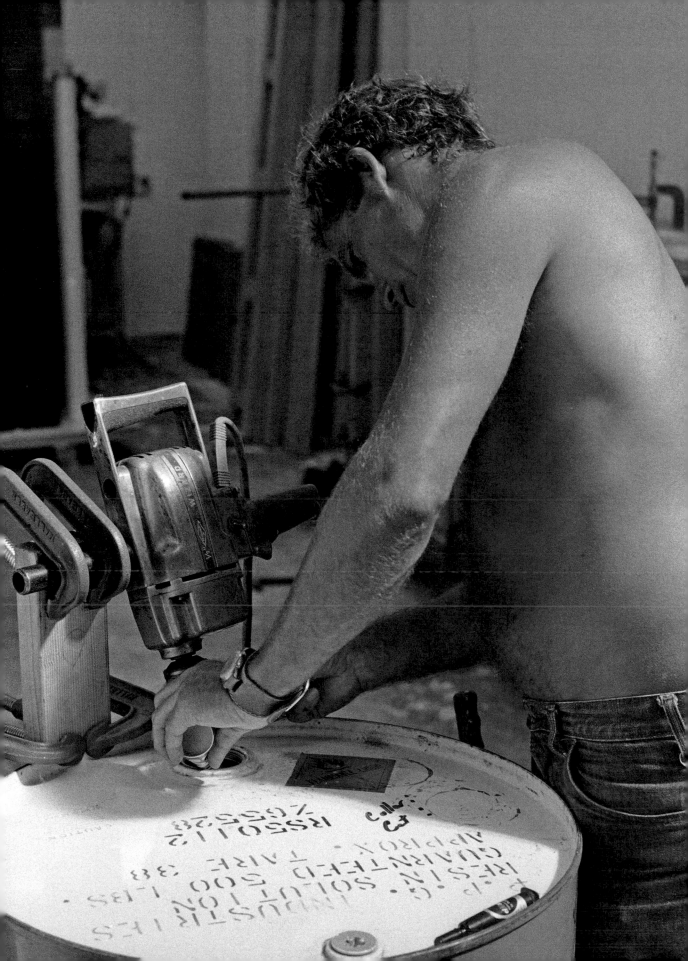

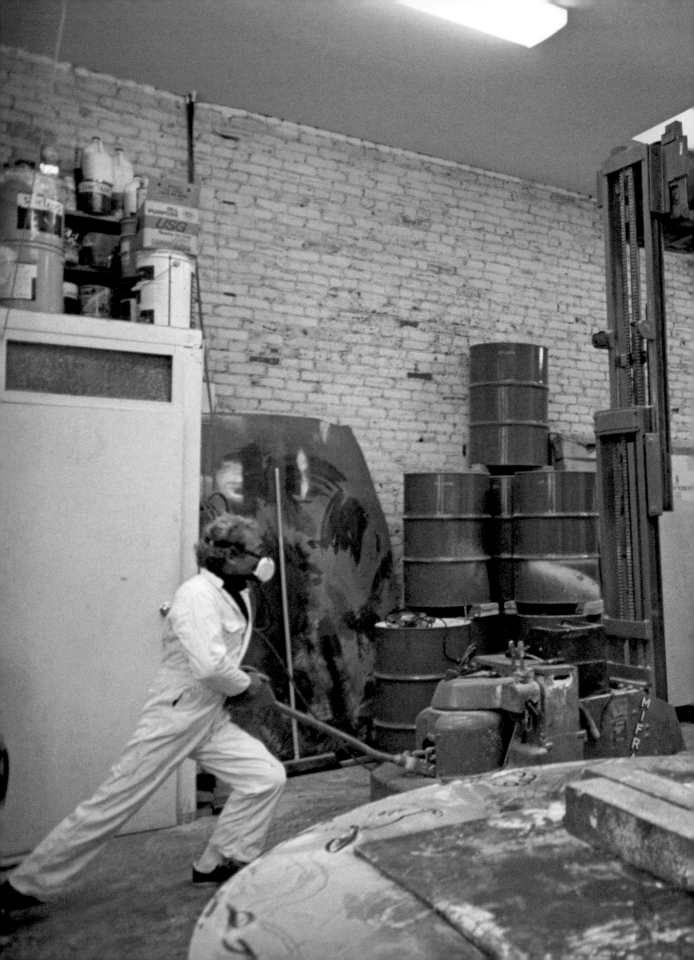

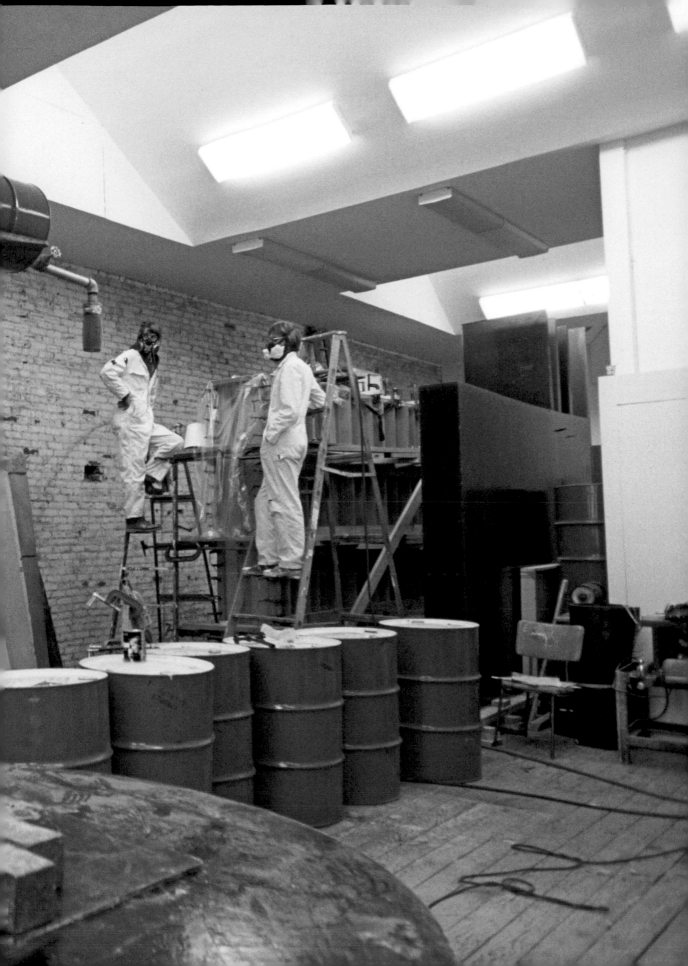

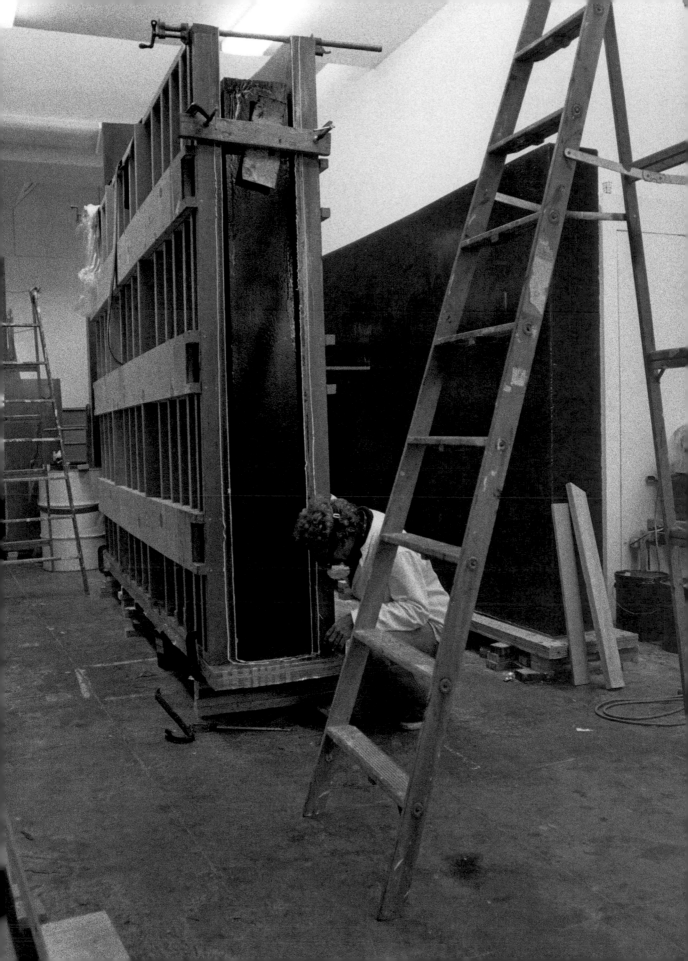

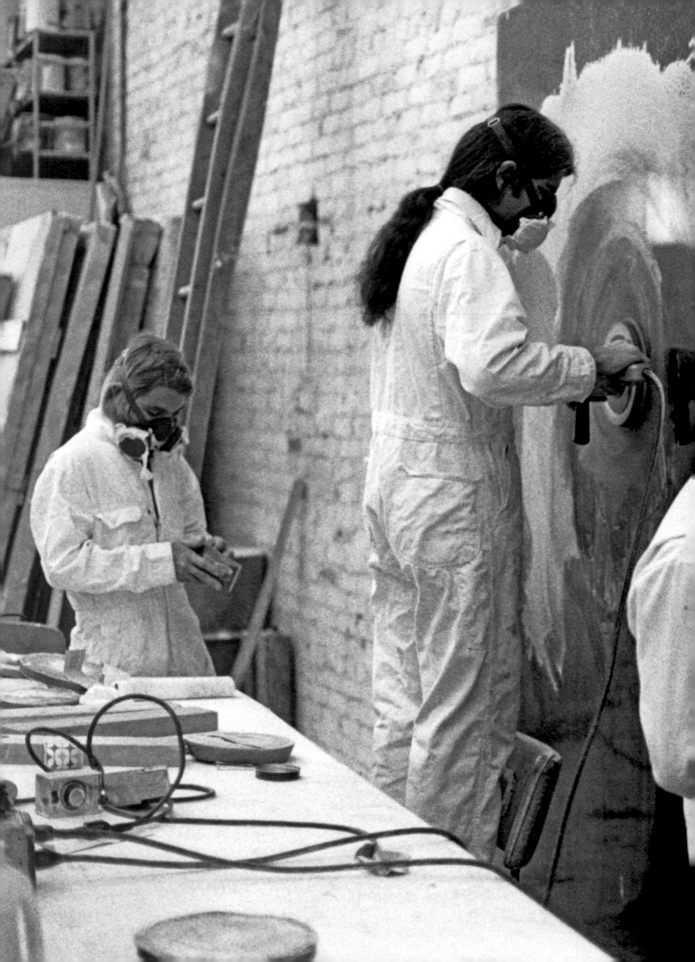

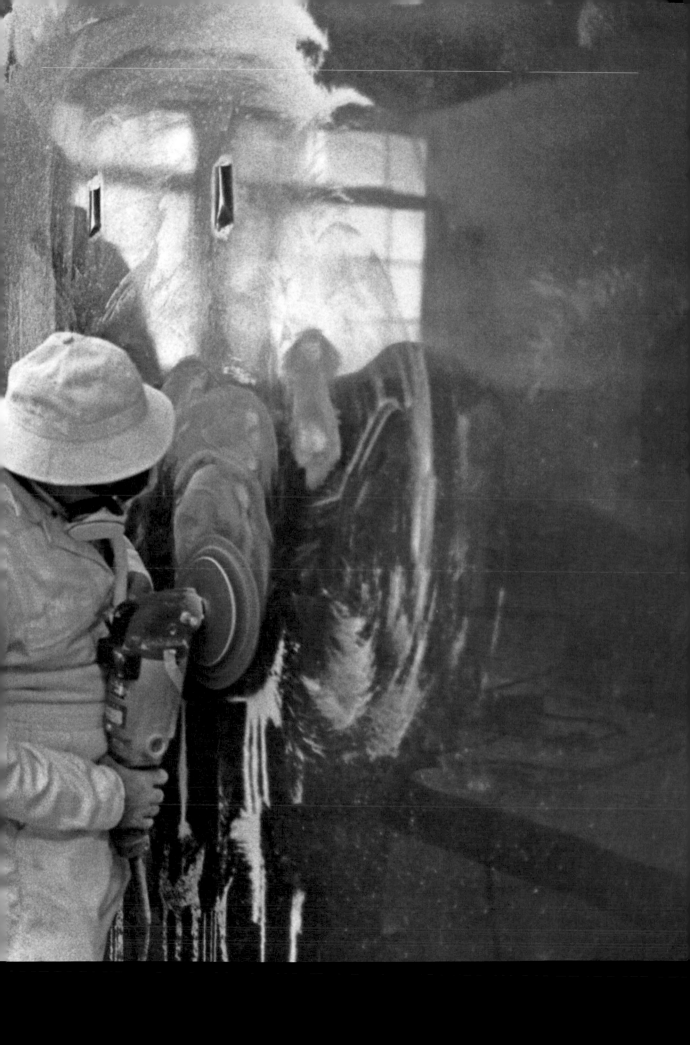

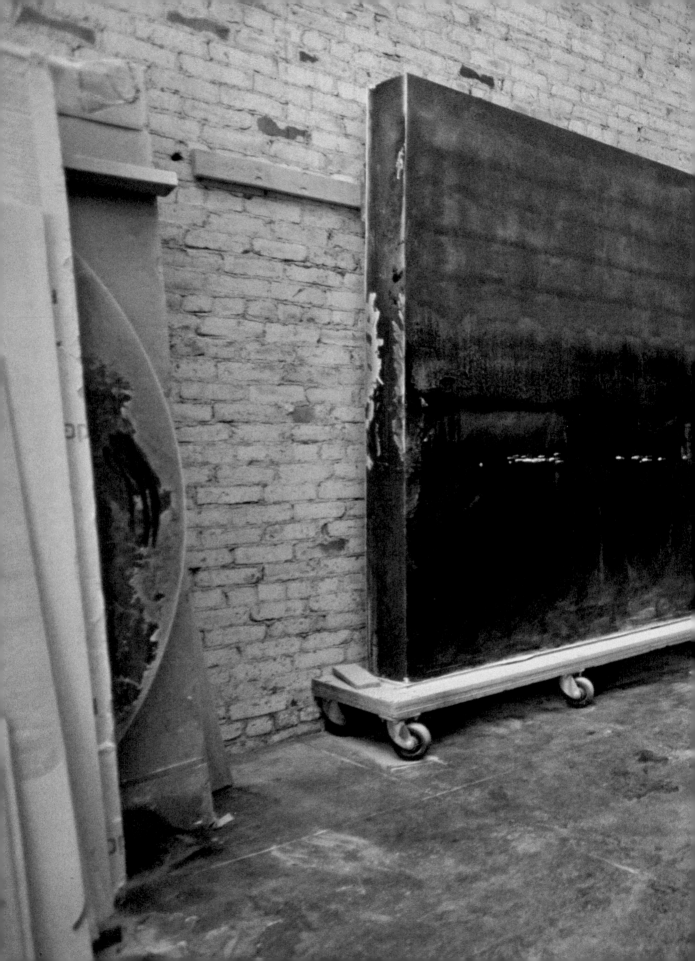

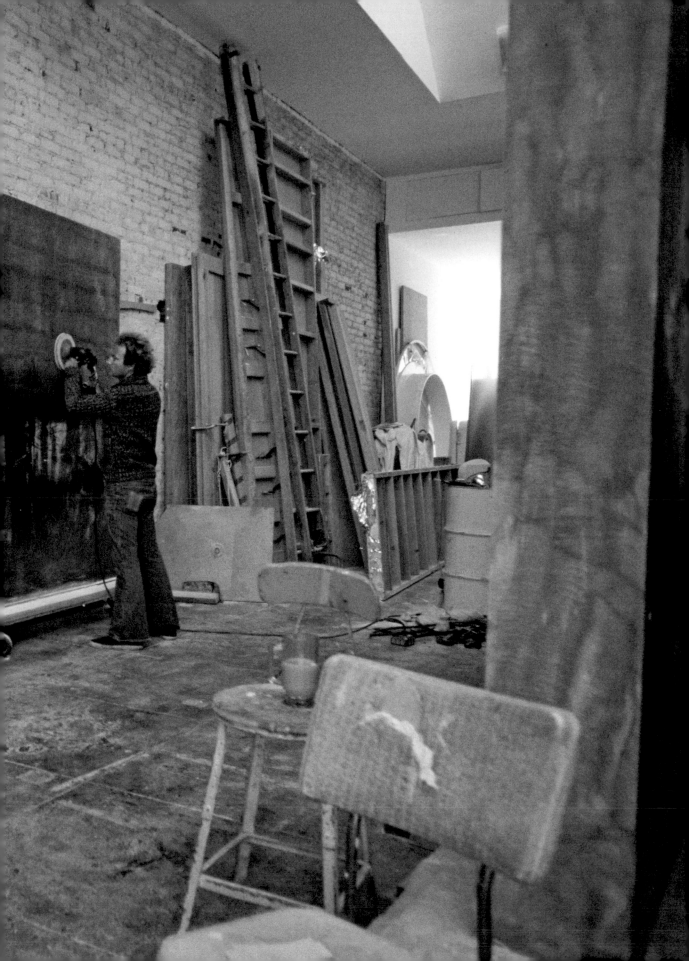

ILLUSTRATIONS

All works by De Wain Valentine, © De Wain Valentine.

PAGE 1

De Wain Valentine, *Gray Column*, 1975–76. Cast polyester resin, 140 x 87 1/2 x 9 1/2 in. (355.6 x 222.3 x 24.1 cm). The work is shown installed at the Getty Center, Los Angeles, for the exhibition *From Start to Finish: De Wain Valentine's "Gray Column."* The piece weighs approximately 3500 lb. (1590 kg). Photo: Rebecca Vera-Martinez.

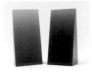

PAGE 5

A shot taken in Valentine's studio in Venice, California, showing the polyester resin being poured into the mold, 1975–76. The barrel remained strapped to the forklift during the process. The resin was forced through a stainless steel reticulated strainer, made for aircraft jet fuel, to ensure that any impurities were removed. Ten barrels of resin, costing approximately $250 each at the time, were used for a piece the size of *Gray Column*. It took up to eighteen hours straight to pour the ten barrels of resin. Photo: © Cathy Weiner.

PAGE 7

Cast polyester resin maquettes, 1976, 23 1/2 x 11 3/4 x 9 3/4 in. (59.7 x 29.8 x 23.5 cm). Valentine cast and polished over fifteen maquettes in preparation for *Gray Column*, in which he experimented with degrees of pigmentation in order to see the level of opacity he would get at various thicknesses of polyester and to see how they would interact with light. These maquettes are displayed in *From Start to Finish*. Photo: Commonwealth Projects.

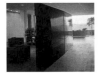

PAGE 8

De Wain Valentine, *Two Gray Walls*, 1975–76, installed in the boardroom of Baxter Travenol Laboratories' corporate headquarters in Deerfield, Illinois, 1977. Although Valentine had intended the piece to be two vertical columns standing side by side, because of modifications by the architects (the ceilings were lowered), Valentine installed the two slabs on their sides. Photo: Courtesy De Wain Valentine.

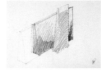

PAGE 9

De Wain Valentine, *Untitled*, 1969. Graphite on paper, 18 x 24 in. (45.7 x 61.0 cm). Although these are not the preparatory drawings for *Gray Column*, Valentine made similar drawings for all of his polyester pieces, in which he established proportions. This drawing is displayed in *From Start to Finish*. Photo: Commonwealth Projects.

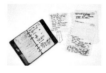

PAGE 10

Pages from Valentine's formula book, 1968–77. The artist kept a notebook in which he jotted down all the details of his experimentation with his MasKast Resin to determine the correct proportions of catalyst to resin. The book also held sketches for new pieces and calculations of the number of barrels of resin he would need for a particular piece. He also recorded the temperature in his studio, another crucial parameter. The formula book is displayed in *From Start to Finish*. Photo: Commonwealth Projects.

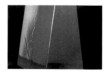

PAGE 11

Detail of one of the *Gray Column* maquettes, which would have originally had the pristine surface characteristic of Valentine's work. Over time the resin has developed a network of ridges on its surface, visible in this photo, taken in raking light. Valentine calls these ridges "grow-outs." The only way to remove them is to resand and repolish the surface. Photo: Stacey Rain Strickler.

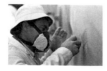

PAGE 12

Valentine sanding down a local surface defect, 1975–76. Photo: Courtesy De Wain Valentine.

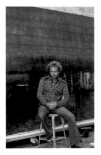

PAGE 13
De Wain Valentine in front of *Gray Column*, 1975–76, during the polishing stage.
Photo: Courtesy De Wain Valentine.

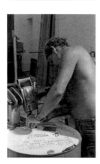

PAGE 14
Valentine weighing out the precise amount of catalyst to be added to the polyester
resin in order to initiate the curing process. The correct proportion of catalyst to
resin was critical to casting large-scale pieces. Too much catalyst would prompt the
resin to cure too fast, would generate dangerous amounts of heat, and could easily
cause the resin to crack. Too little catalyst would prevent complete curing.
Photo: © Cathy Weiner.

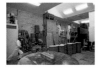

PAGE 15
Valentine pouring the catalyst (in the paper cup) into the barrel of resin. The three
components—resin, pigment, and catalyst—would then be thoroughly mixed together.
To ensure complete mixing, he used a propeller blade that was attached to the motor
(visible by Valentine's hands) and inserted inside the drum. Mixing a barrel would
often take up to an hour. Photo: Sean Valentine.

PAGES 16–17
A studio shot showing the casting of *Gray Column*, 1975–76. Valentine (left) pushes
a forklift toward the mold. Its forks are raised to the maximum height, and a 500 lb.
(227 kg) barrel of polyester resin is strapped on. Chris D'Arcangelo (middle) and Keith
Anderson (right) stand on ladders waiting to guide the barrel's nozzle into the mold.
One of the *Gray Column* pieces can be seen at the right edge, lying on its side. Photo:
© Cathy Weiner.

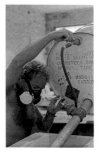

PAGE 18
Valentine pouring the polyester resin from the barrel into the mold. The PPG marking
is visible on the barrel. It was important to regulate the flow of the resin. Compressed
air was introduced via the upper valve to create a slight pressure inside the barrel
that would help force all the resin out. Photo: Sean Valentine.

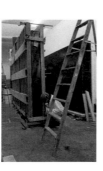

PAGE 19

Valentine inspecting the base of one of the *Gray Column* polyester slabs. After the resin had cured, the mold would be disassembled. Here, the wider end of the mold has been removed. The mold was constructed from thick particleboard and reinforced with wooden crossbeams, and the sides were clamped together. As a structure it needed to withstand the high levels of heat and pressure that were generated during the curing process. Several slabs were usually made off the same mold. The other slab used for *Two Gray Walls* is visible on the right; it is already sanded and polished. Photo: Courtesy De Wain Valentine.

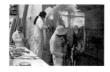

PAGES 20–21

Valentine (right) and two of his assistants, Nelson Valentine (left) and Rob Janiger (center) polishing *Gray Column* in 1976. The polishing is crucial as it changes the rough and opaque surface into a perfectly smooth one, translucent and reflective. From the rough-sanding to the final fine-polishing, the process took weeks. The ability of the artwork to interact with light depends on the perfection of the polishing process. Photo: Courtesy De Wain Valentine.

PAGES 22–23

Valentine polishing *Gray Column* in 1976. The sanding stage is finished, and Valentine is doing the final polishing. Photo: Courtesy De Wain Valentine.

PAGE 31

De Wain Valentine (center) with two of his studio assistants, Chris D'Arcangelo (left) and Keith Anderson (right). They wear respiratory masks as protection against the toxic fumes of the polyester resin. Photo: © Cathy Weiner.

ACKNOWLEDGMENTS

From Start to Finish: De Wain Valentine's "Gray Column" would not have been possible without the support and guidance of many people. First on this list must be De Wain Valentine himself, who welcomed us into his life with enthusiasm, warmth, and humor and who opened his studio and archives without reservation. It has been an extraordinary journey bringing this exhibition to fruition, and we are grateful to him and his partner Kiana Sasaki for their generosity in sharing their memories and thoughts, not to mention sushi and fine wines.

There were many others who also gave us valuable insights into the Venice Beach art scene of the 1970s, the period in which *Gray Column* was cast, including Keith Anderson, Larry Bell, Jean-Luc Bordeaux, Jack Brogan, Doug Chrismas, Harry Drinkwater, Frank Gehry, Bob Irwin, Rob Janiger, Helen Pashgian, Cathy Weiner, and Eric Wilson, and along with them, Robin Clark, Jennifer Kellen, Julia Kornfield, Beau Ott, and Annie Philbin, who provided further context and insights for various aspects of the project.

None of this would have been possible without the continuous support and trust from GCI director Tim Whalen and associate directors Jeanne Marie Teutonico and Kathleen Gaines. Although so many of our colleagues at the GCI were involved to some degree in this under-taking—and we are grateful for all their patience and assistance—particular mention goes to Holly Brobst, Sheila Cummins, Angela Escobar, Valerie Greathouse, Brenda Harrop, Emily MacDonald-Korth, Gary Mattison, Tom McClintock, Alan Phenix, and Anna Zagorski, all of whom helped directly and enthusiastically and offered many useful suggestions.

Our thanks also go to colleagues at our sister programs: from the J. Paul Getty Museum, David Bomford, Robert Checchi, Brian Considine, Elie Glyn, Sally Hibbard, Quincy Houghton, Chris Keledjian, Amber Keller, Clare Kunny, Kevin Marshall and Mike Mitchell (and their talented team of preparators), Kanoko Sasao, Stacey Rain Strickler, Toby Tannenbaum, Julie Wolfe, and all the others involved in the practicalities of planning this exhibition; from the Getty Research Institute, Lucy Bradnock, Joshua Machat, Andrew Perchuk, Rani Singh, Catherine Taft, and those with whom we collaborated on the broader Pacific Standard Time research study; and from the Getty Trust, Melissa Abraham and the Trust Communications team.

For generously sharing with us many of the photographs featured in this catalogue and in the DVD, our gratitude goes to Harry Drinkwater and Cathy Weiner. We would also like to thank Lucy Bradnock and Robin Clark for making excellent suggestions on our texts.

A special mention is owed to the team at Commonwealth Projects, who were always a pleasure to work with, in particular Erik Barnes, Kyle De Lotto, Daniel DeSure, Jesse Fleming, Michelle Park, and Nicholas Trikonis, for their outstanding design of this catalogue and for the documentary filmmaking.

And to Agnes Gund, our sincere thanks for her generosity in support of this project.

Tom, Rachel, and Emma

ABOUT THE AUTHORS

Tom Learner is senior scientist and head of Modern and Contemporary Art Research at the GCI. He has a PhD in chemistry (University of London, 1997) and a diploma in the conservation of easel paintings (Courtauld Institute of Art, London, 1991). Before joining the GCI in 2007, he was senior conservation scientist at the Tate Gallery in London, where he had worked from 1992. He is currently the coordinator for the Modern Materials and Contemporary Art Working Group of ICOM-CC (International Council of Museums Committee for Conservation), and he sits on the advisory committees for INCCA (International Network for the Conservation of Contemporary Art) and Rescue Public Murals.

Rachel Rivenc is assistant scientist at the GCI with the Modern and Contemporary Art Research group. She holds an MA in paintings conservation (Paris I Sorbonne, 2001). She was a paintings conservator in private practice and taught paintings conservation at the University of Malta before joining the GCI in 2006, where she studies paints and plastics used in contemporary art. She is currently assistant coordinator for the Modern Materials and Contemporary Art Working Group of ICOM-CC.

Emma Richardson is currently a postdoctoral research fellow at the GCI. She has a PhD in conservation science (University of Southampton, 2009) and an MSc in analytical chemistry (Sheffield Hallam University, 2004). In recent years her research has included the noninvasive characterization of polymers by near infrared spectroscopy, the in situ monitoring of tensile stresses in textile artifacts, and the effects of plasticizer migration on the mechanical properties of cellulose acetate based film.

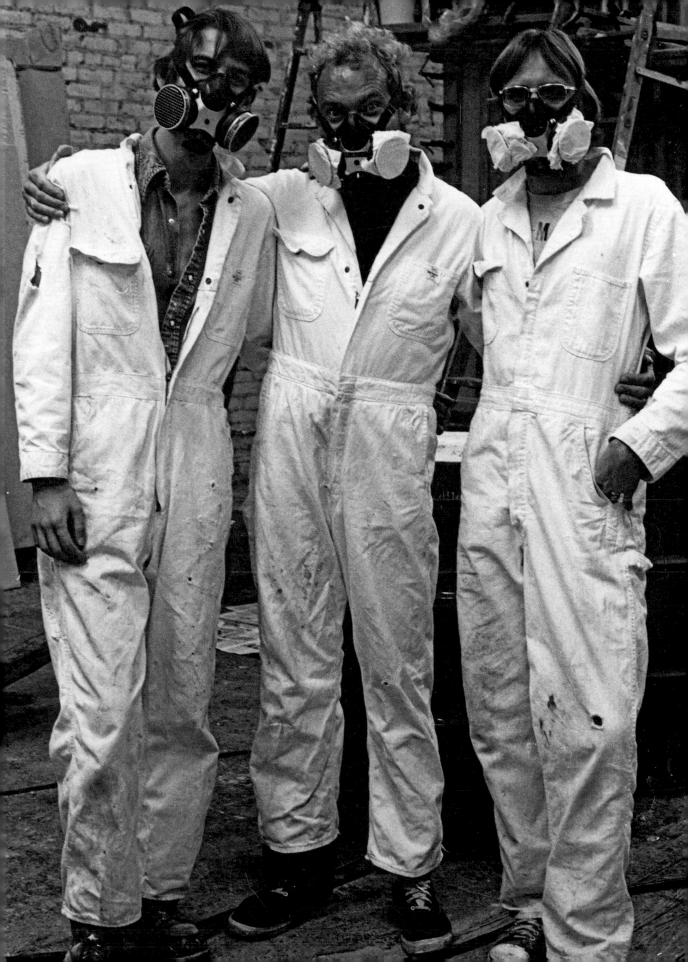

FROM START TO FINISH:
THE STORY OF *GRAY COLUMN*

Note to Accompanying DVD

From the Venice Beach art community in the 1970s to the practicalities of casting a thirty-five-hundred-pound slab of polyester—as well as the implications for storing, displaying, transporting, and conserving such a colossal work of art—there is so much more to the story behind De Wain Valentine's *Gray Column* than has been possible to portray in this catalogue. To reveal more of these behind-the-scenes events, a film crew followed the GCI team for six months as they researched Valentine and his working methods and prepared for the exhibition *From Start to Finish: De Wain Valentine's "Gray Column,"* which opened in September 2011 at the Getty Center in Los Angeles. Largely through interviews with Valentine and his contemporaries, his studio assistants, collectors, conservators, curators, and scientists, this 30-minute documentary recounts more of the remarkable story of the obstacles that had to be overcome to cast pieces the size of *Gray Column,* the importance and influence of Valentine's work, the issues related to its conservation, and the challenges involved in preparing for such an exhibition.

A Commonwealth Projects Production
Directors: Daniel DeSure & Erik Barnes
Editor: Erik Barnes
Assistant Editor: Benjamin Caro
Director of Photography: Jesse Fleming
Operator: Nicholas Trikonis
Sound Designer: Nick Huntington
Location Sound: Reza Moosavi
Art Director: Michelle Park
Motion Graphics Designer: Gregory Coats
Writer: Kyle De Lotto

Special Thanks to Jacob Waldron and Russell Bell.